Dr Dave Colton

UNICORN

INTRODUCTION

I spend a lot of time thinking, 'what if?'

What if Beatrix Potter didn't actually like rabbits, or what if Hitler had been a better artist? What if Lisa del Giocondo had not only been painted by Leonardo, but collaborated on his inventions as well; or what if Mondrian could visit a modern-day museum and see the endless consumer items for sale featuring his work? This was the starting point for this collection of drawings; playing with characters that I think I know well, not concerning myself with facts or time or place, but imagining other aspects to their lives, making unlikely connections and giving them human foibles and twenty-first-century concerns.

Soon I began to look at works of art too … These images and their stories, like the artists who created them, have been a constant in my life since I went to art college. What if I tweaked them a little? What if I made up stories about them? Imagined different scenarios, added captions …?

I discovered that this gave them new purpose, allowing them to live again but in a new context, and possibly for a new audience too. I agree with the artist and philosopher Joseph Kosuth who suggested that art lives by influencing other art, not by just existing as the physical residue of the artist's ideas. In this way we can collaborate with anyone we wish. This book then, is my unlikely collaboration with some of the western world's greatest artists, writers and philosophers. I hope you enjoy it!

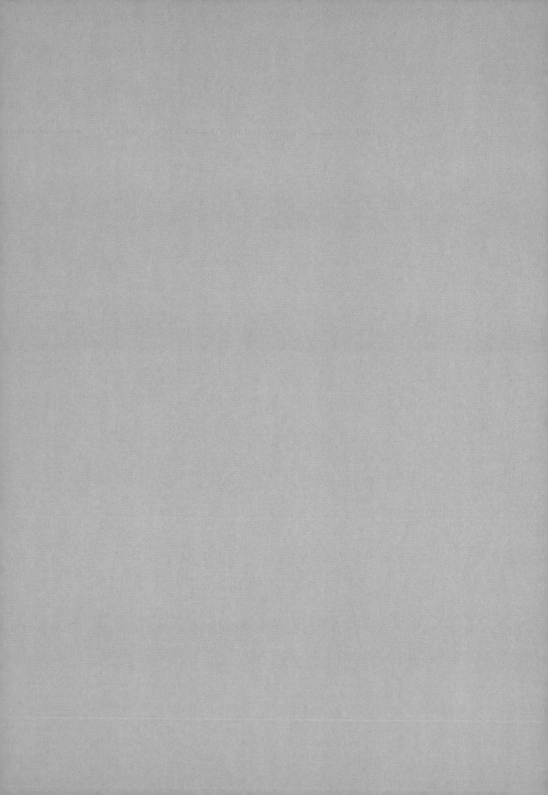

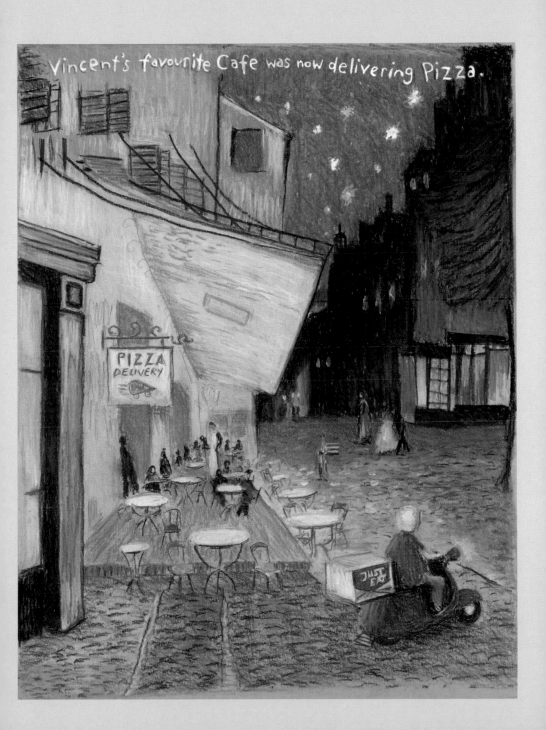

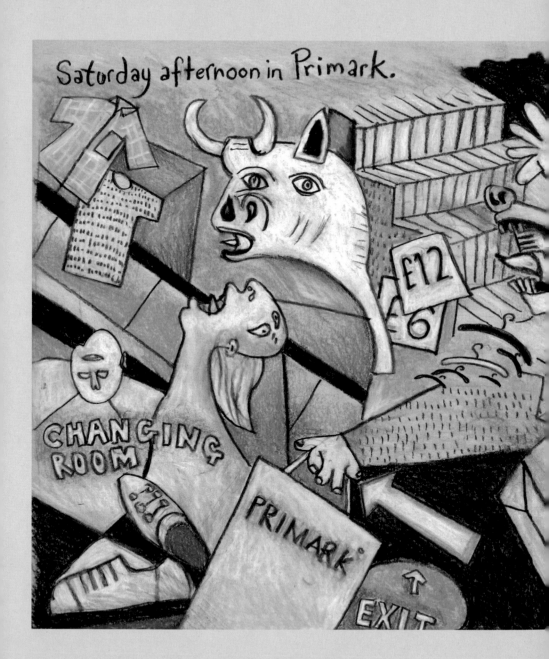

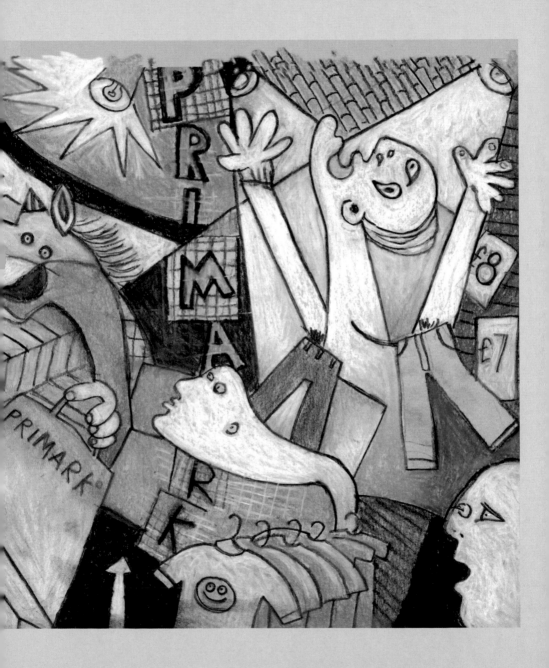

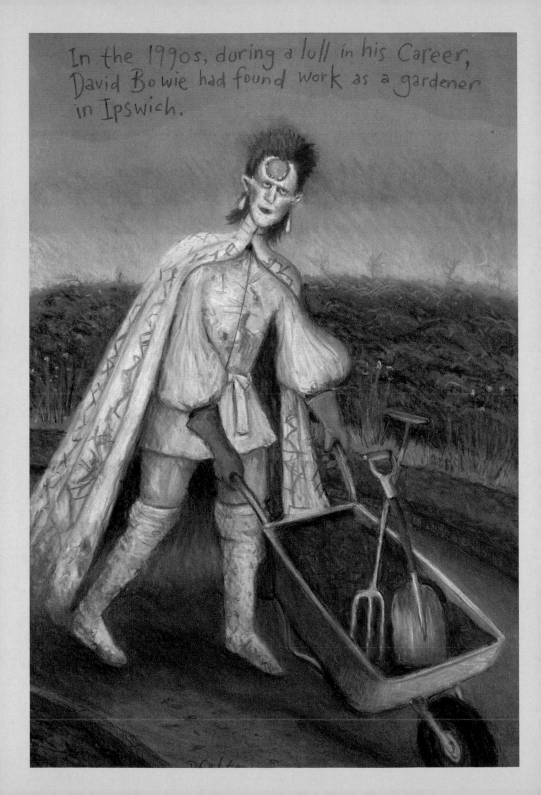

In the 1990s, during a lull in his career, David Bowie had found work as a gardener in Ipswich.

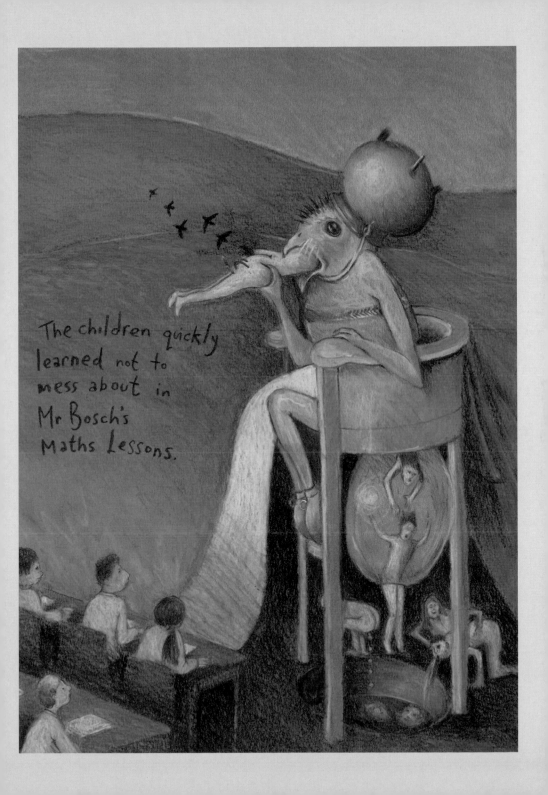

The children quickly learned not to mess about in Mr Bosch's Maths Lessons.

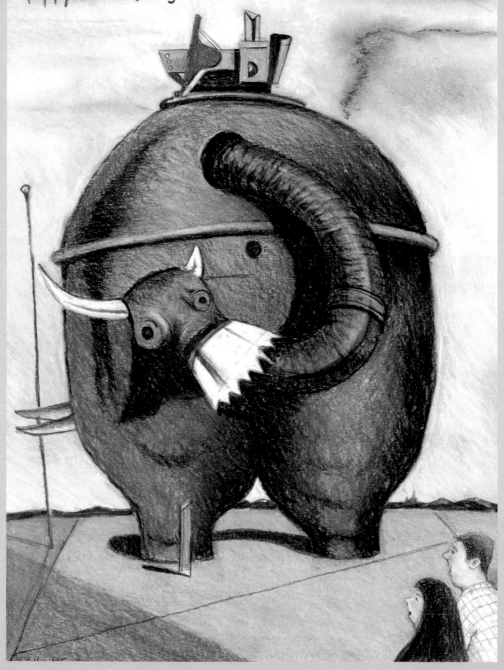

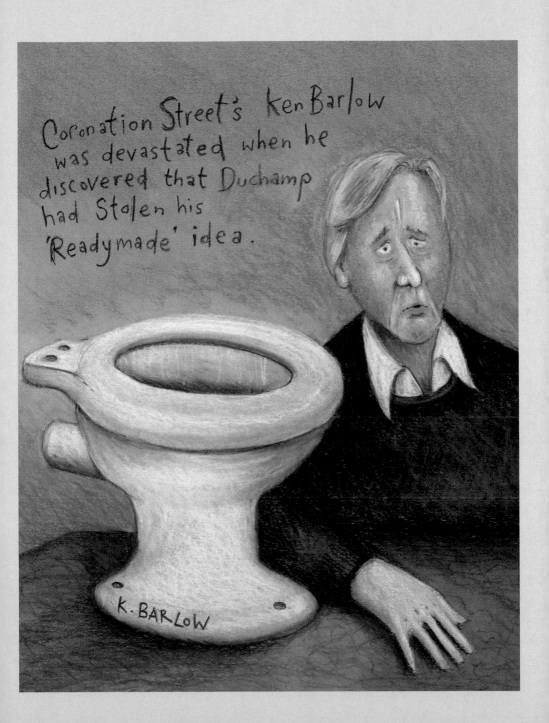

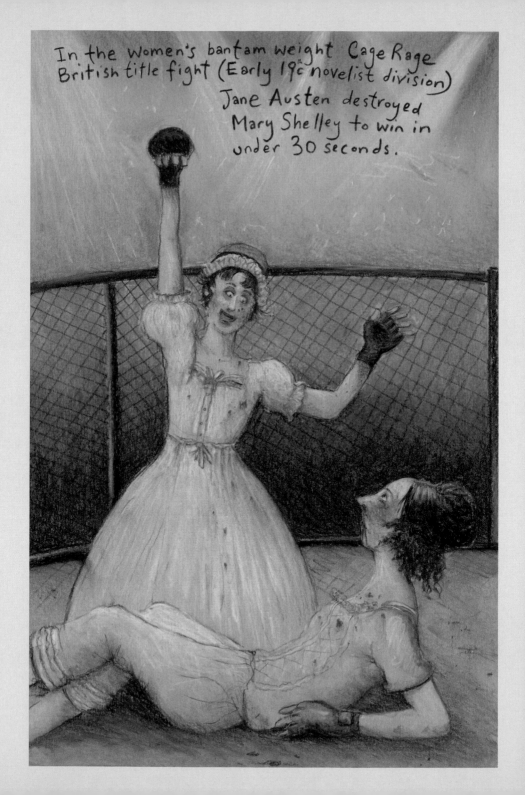

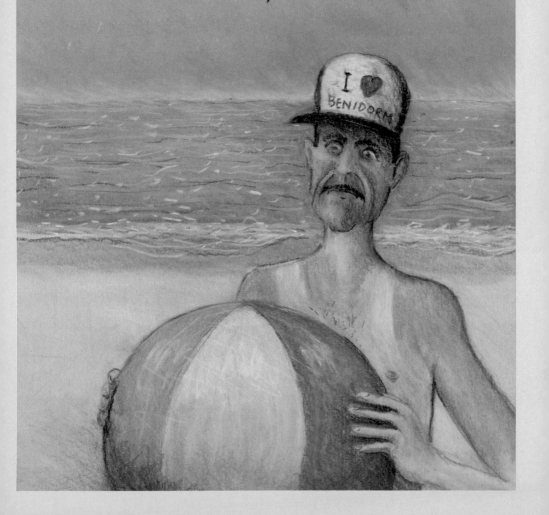

Just when things
could'nt get any
worse for
King Nebuchadnezzar,
He'd lost his bloody
contact lens again.

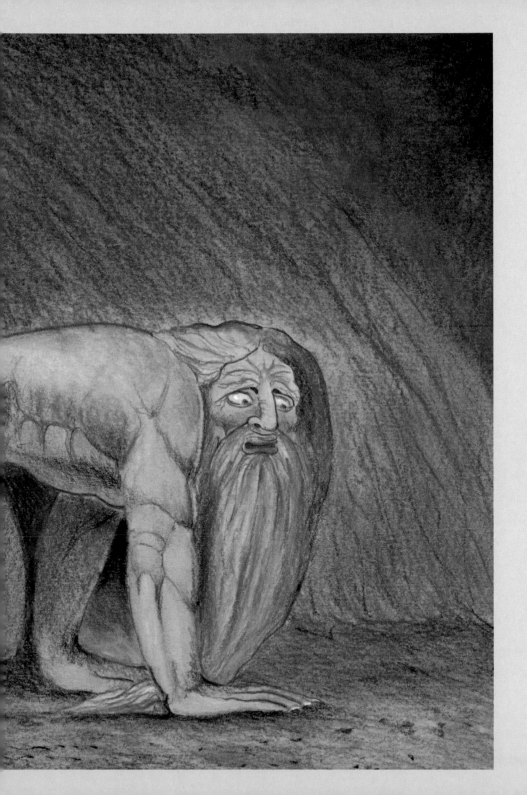

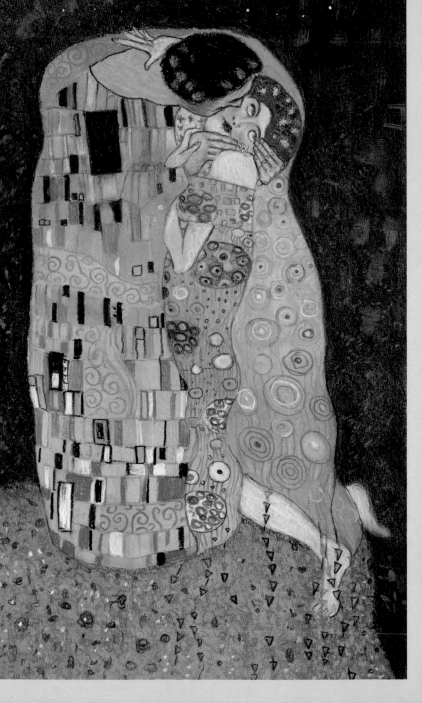

In 1977 Elvis was abducted by 'Aliens'. When they returned him to Earth 40 years later, he discovered that his house had been turned into a museum and that he could only get work impersonating himself.

The look that says you've spent a tenner on Lottery scratchcards and won nothing.

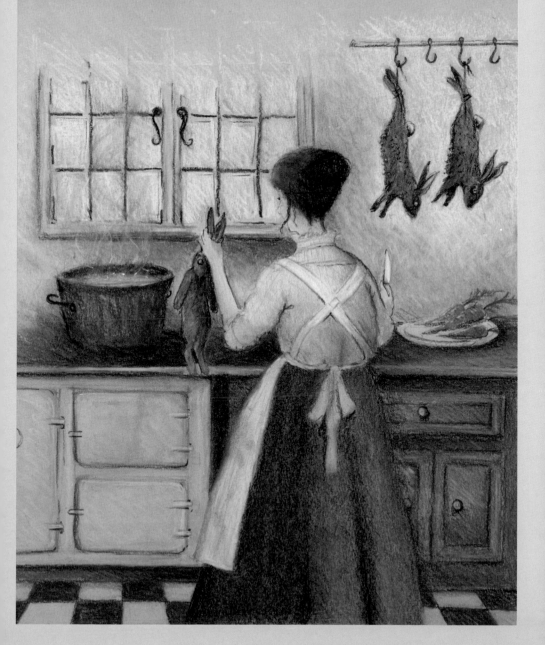

Preparing dinner one day...
Beatrix Potter had an idea for a Children's book.

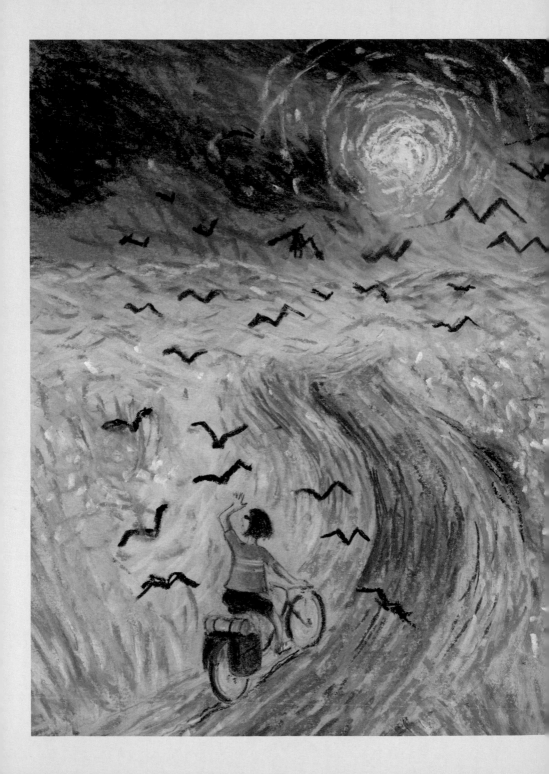

she longed to be back
in a Dali painting,
with soft sand and
open Spaces...

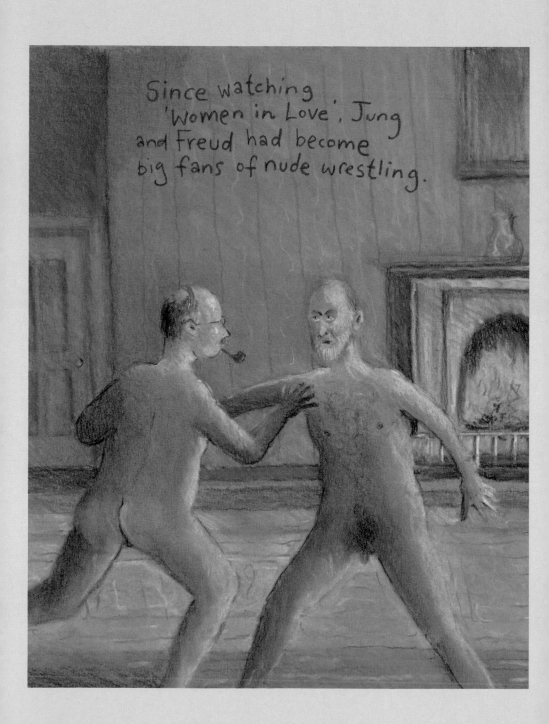

DH Lawrence, bored with his worthy, arty novels, created an alter ego, and went on to enjoy a much more rewarding career writing romantic fiction.

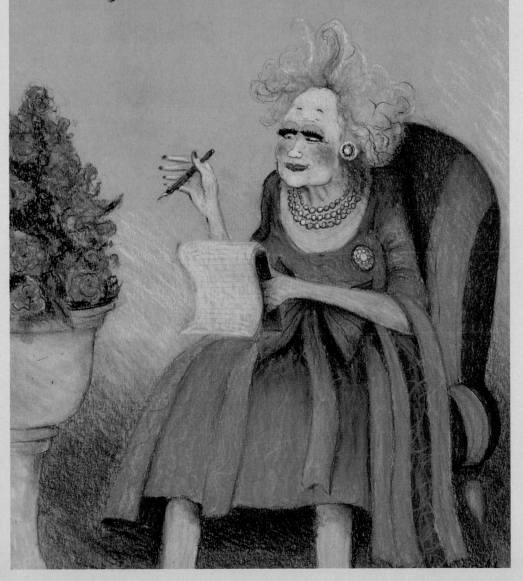

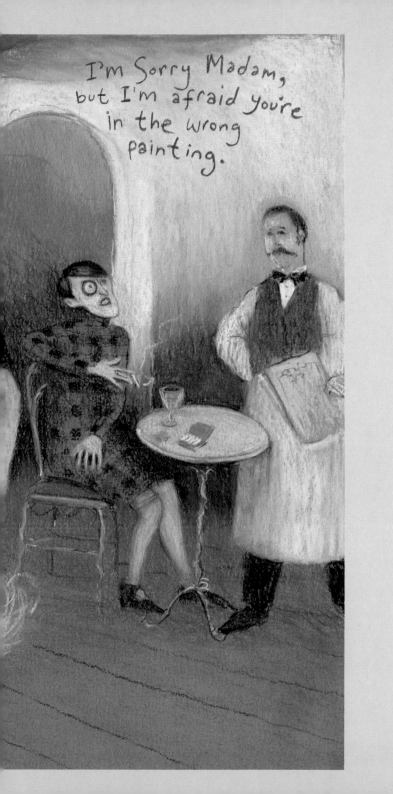

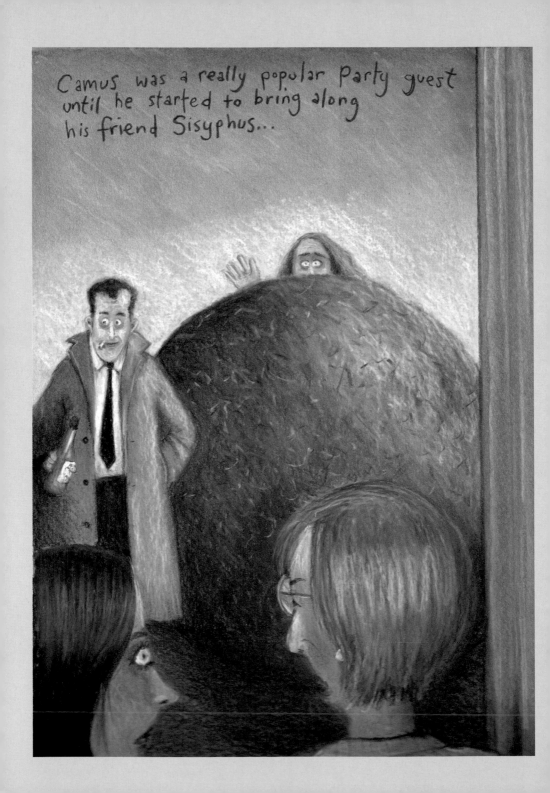

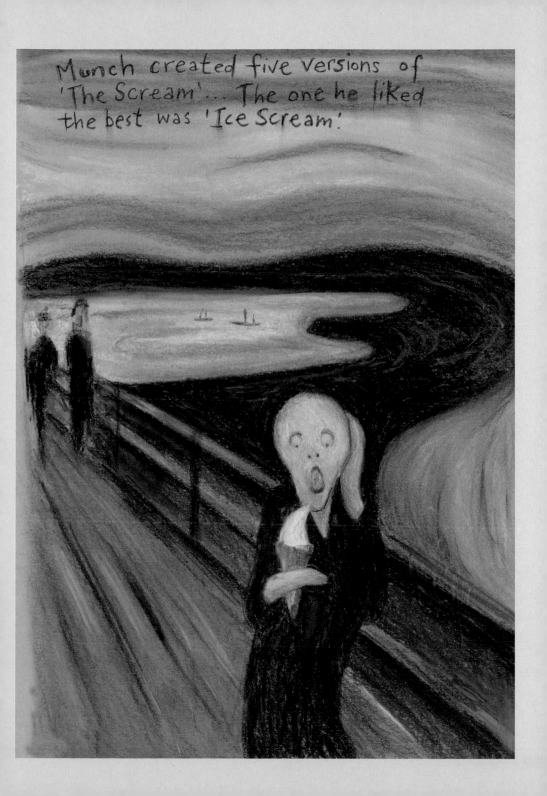

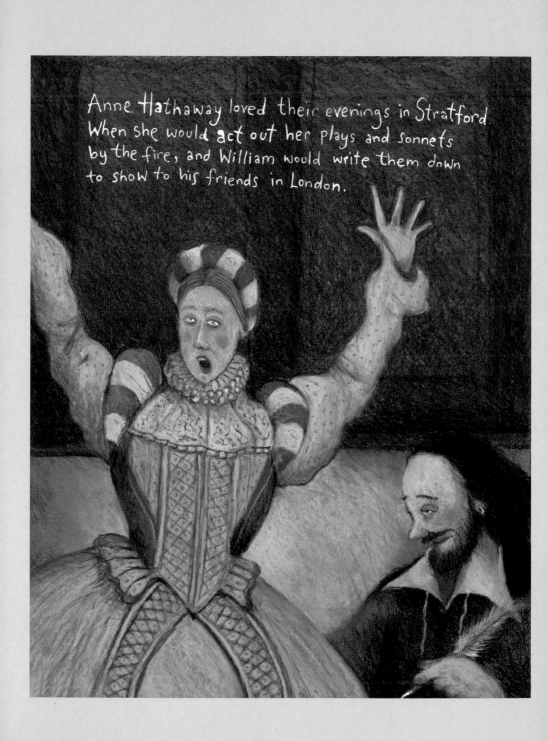

Anne Hathaway loved their evenings in Stratford. When she would act out her plays and sonnets by the fire, and William would write them down to show to his friends in London.

AT the Velasquez school for girls...
The new 'Retro' uniform had not gone down
well with the Pupils or
the Parents.

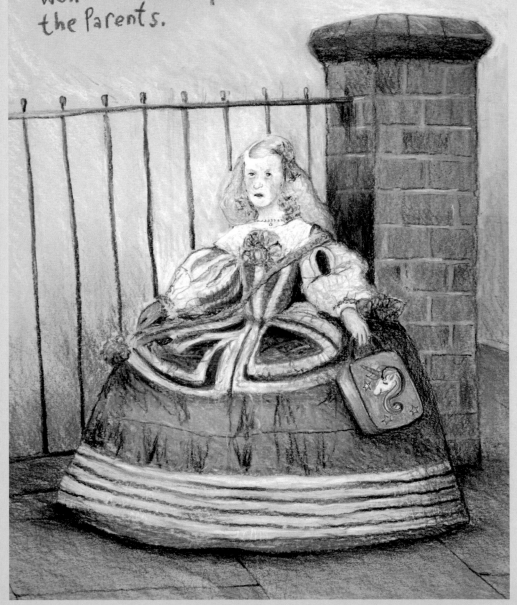

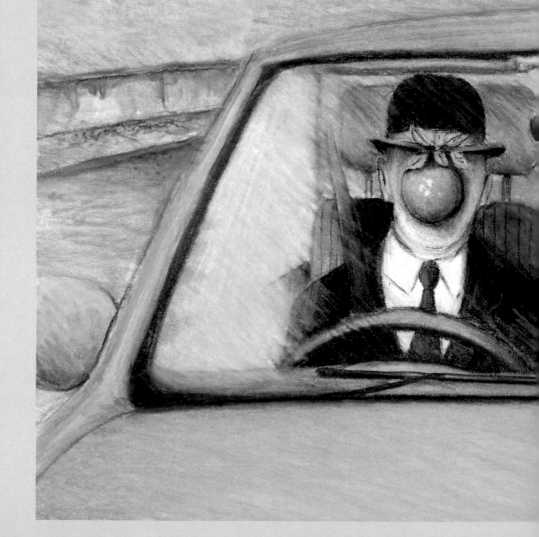

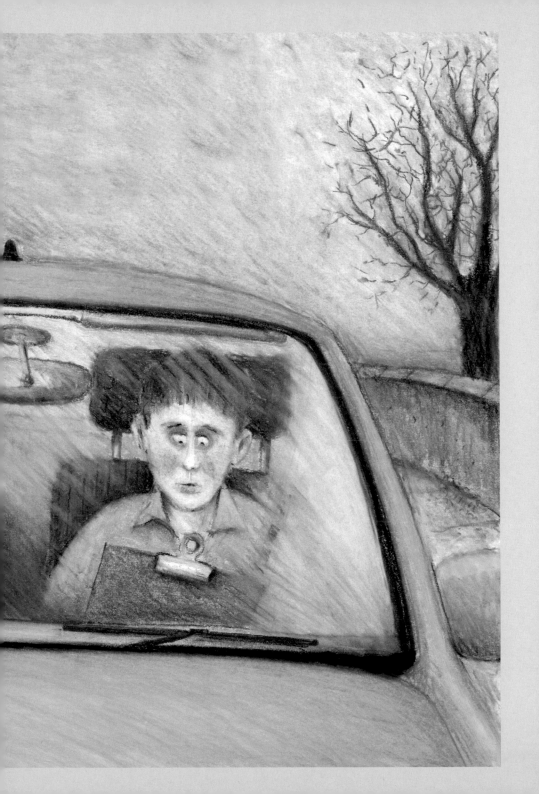

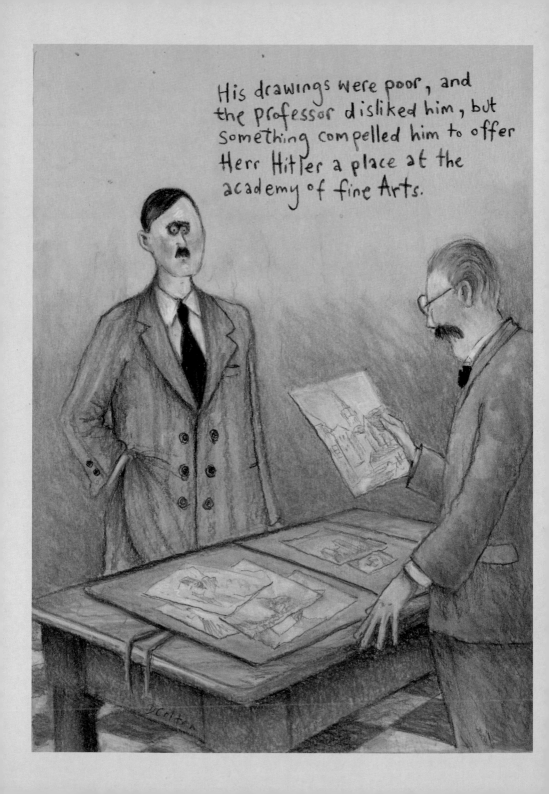

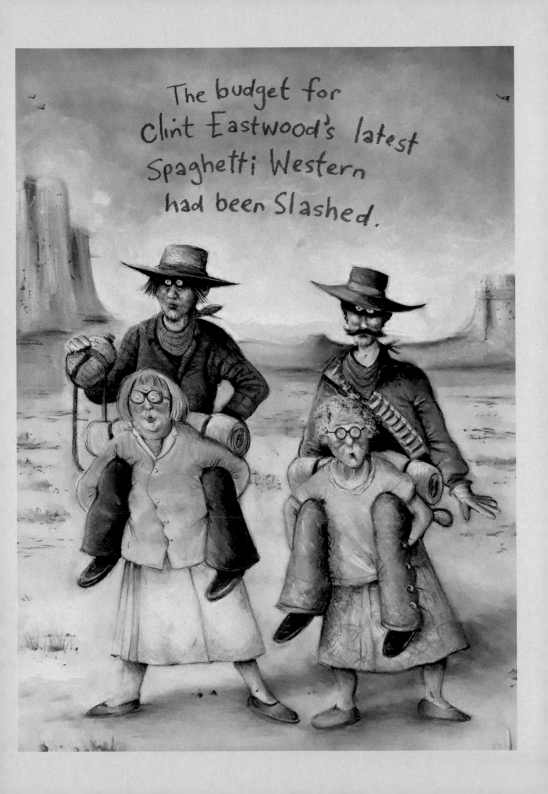

Contrary to popular belief, Vincent actually lost his ear whilst staying with his friend Dali.

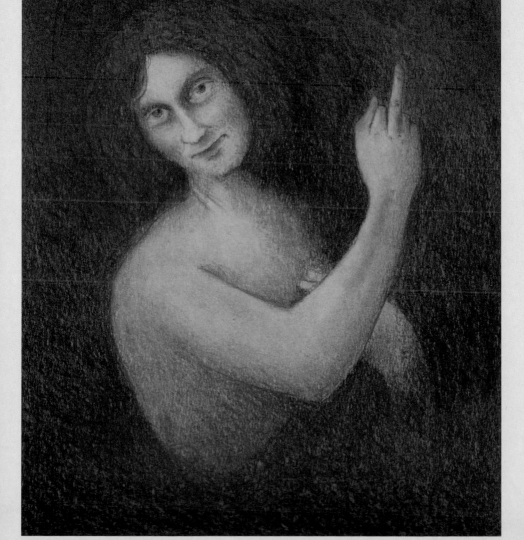

St John's rebellious
 Twin brother Kevin.

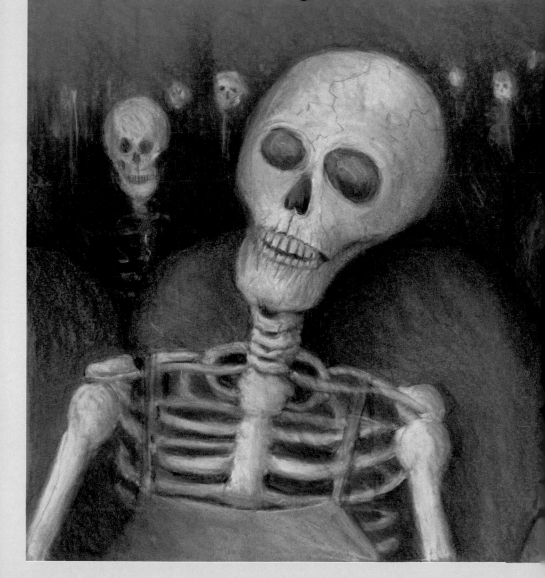

The first performance of
John Cage's 40 years 33 days
had been a great success.

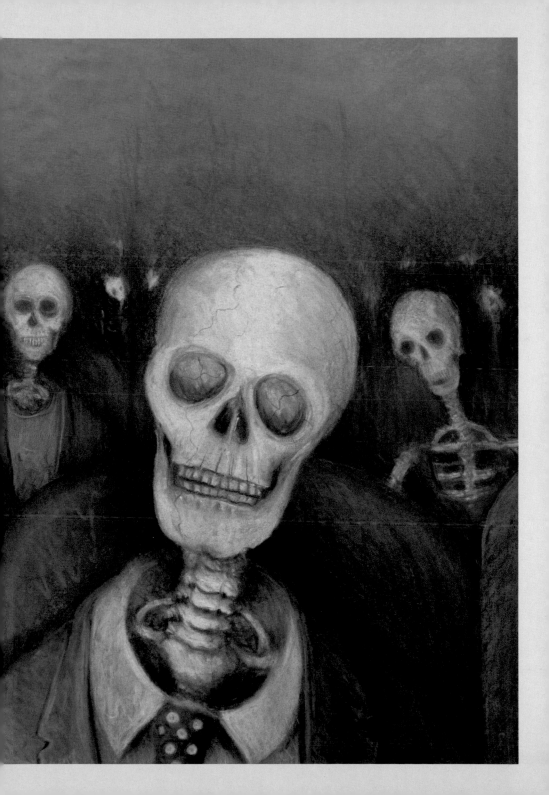

He may be the Ancient of Days, but that kitchen floor won't clean itself.

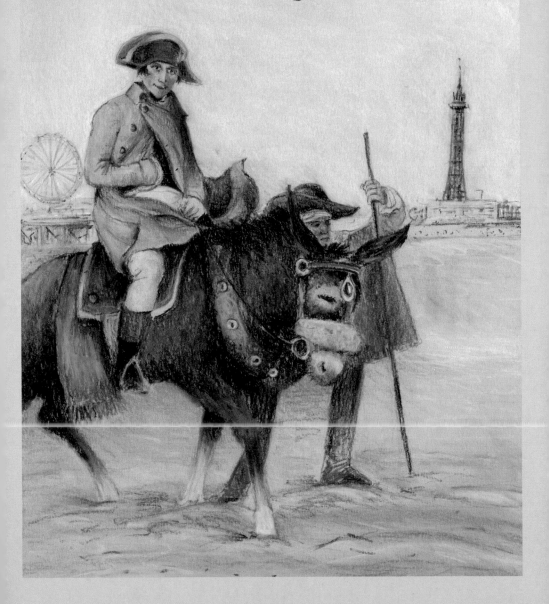

Paul Delaroche's lesser known painting of Napoleon on holiday in Blackpool.

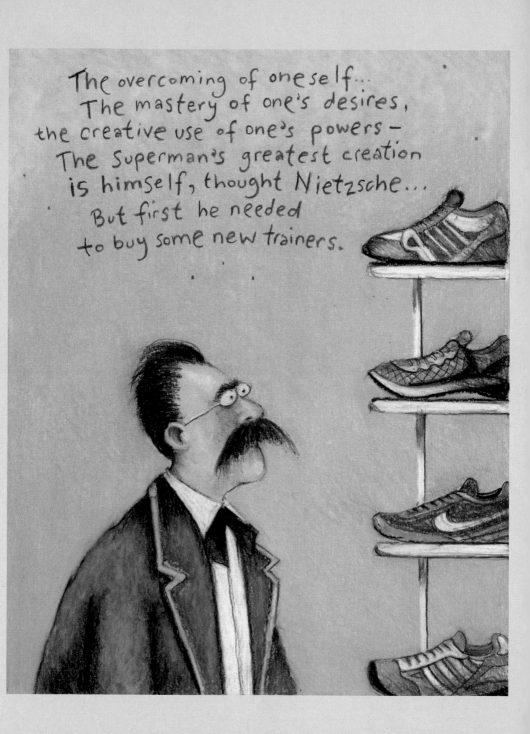

With the money he made from his book 'Das Kapital', Karl was able to buy himself a luxury apartment in Dubai.

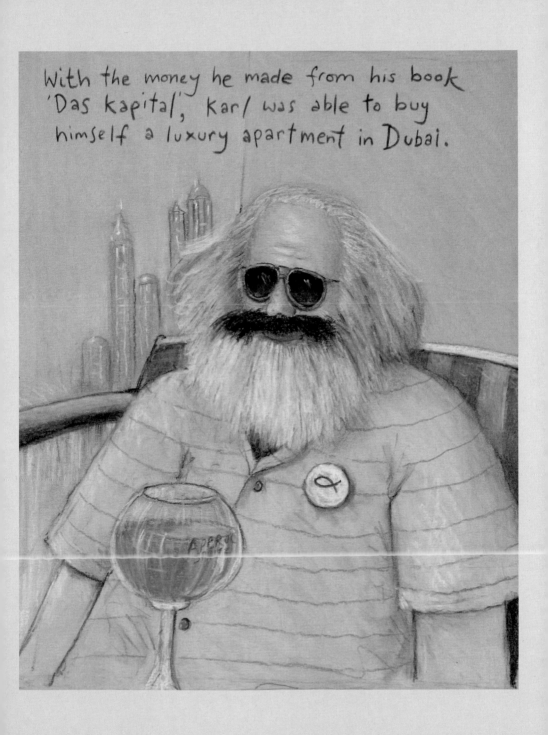

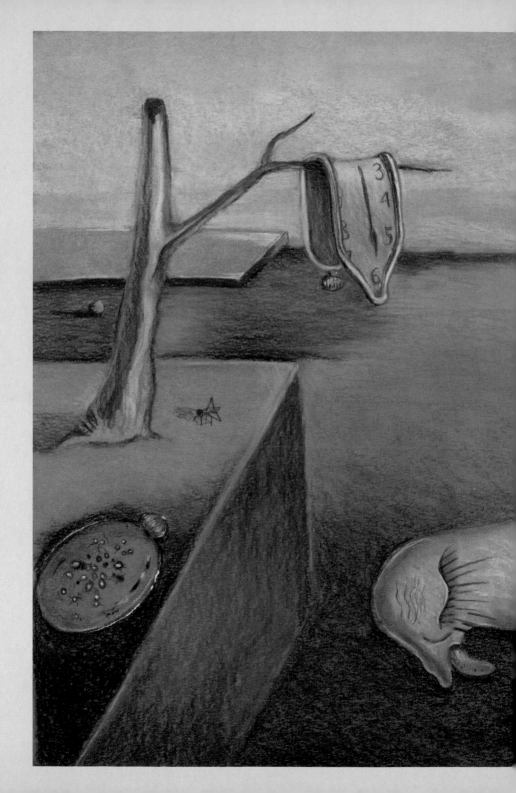

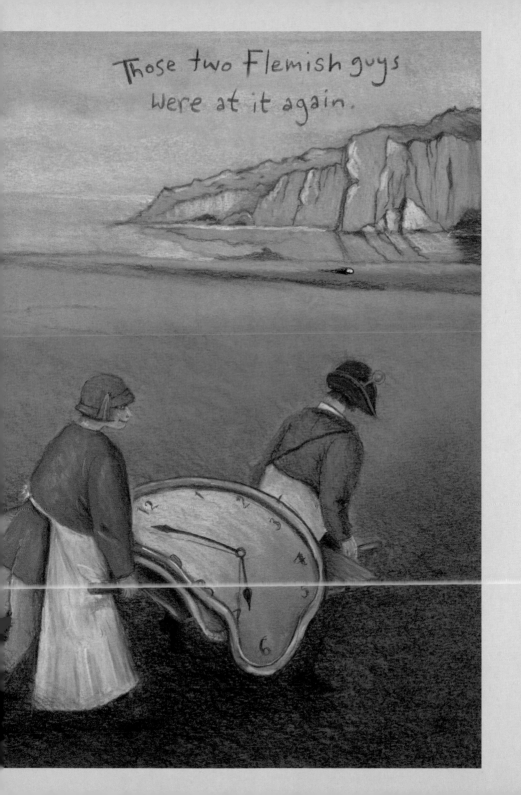

Nijinsky retired from dancing and moved to a new housing development in Wolverhampton.

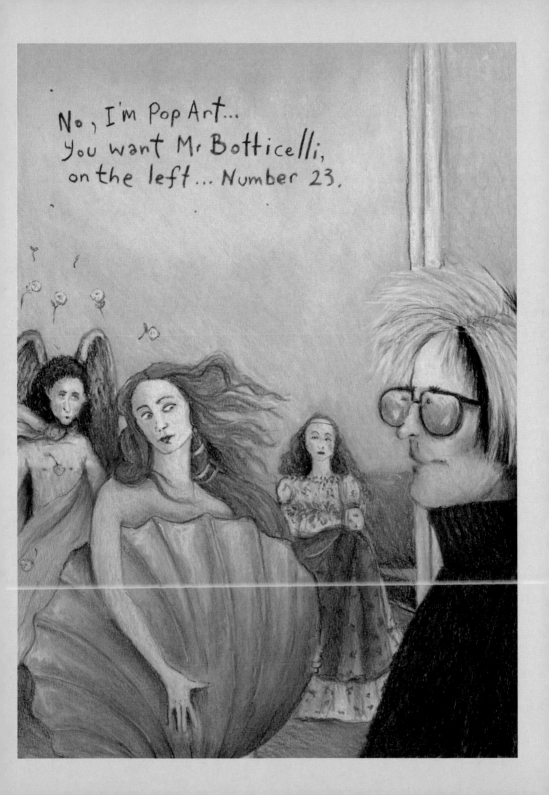

Sometime after starting work on his 10th Symphony, Beethoven became obsessed with TikTok...

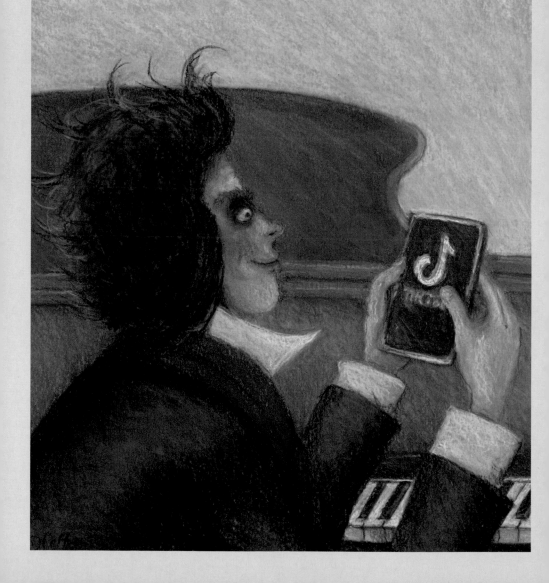

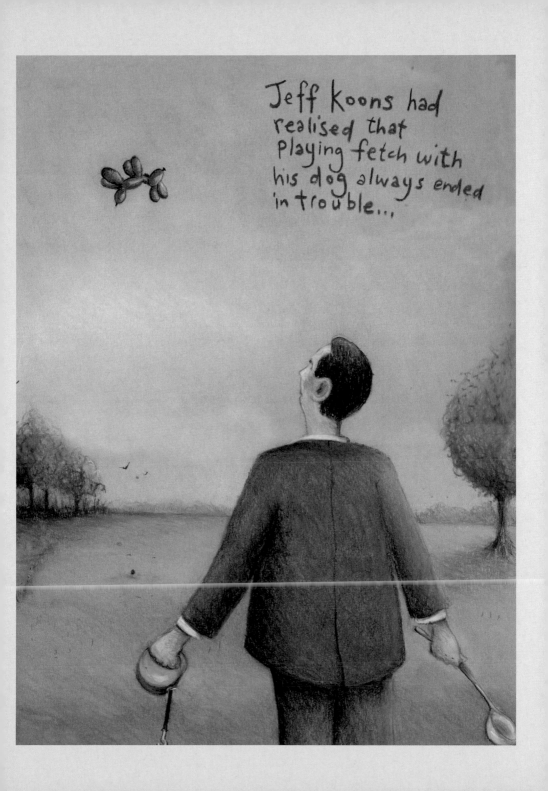

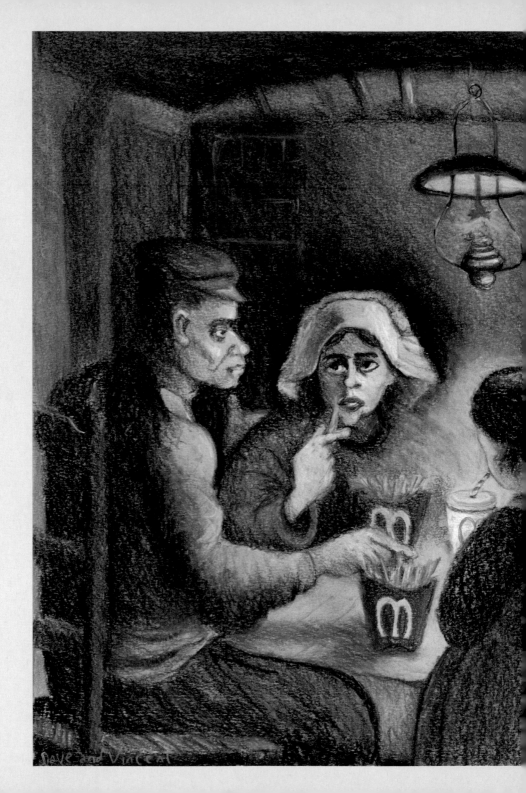

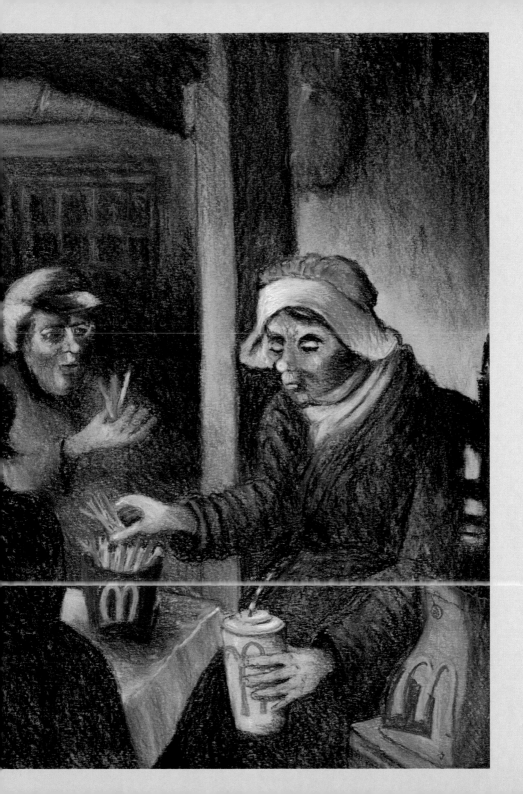

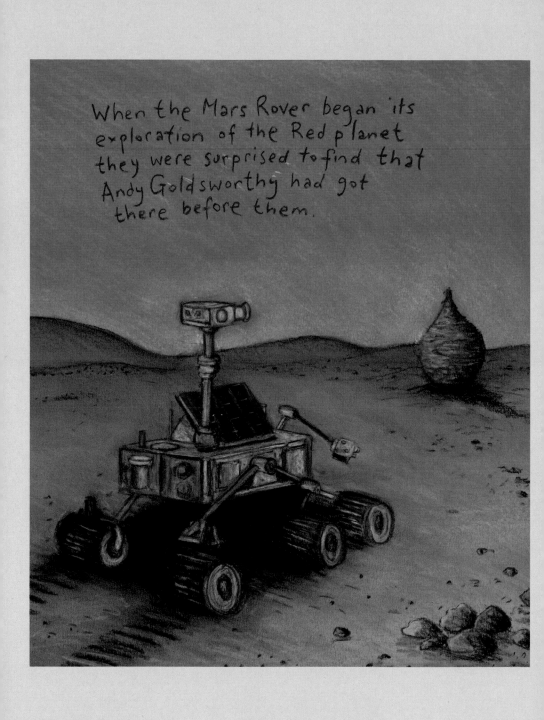

When the Mars Rover began its exploration of the Red planet they were surprised to find that Andy Goldsworthy had got there before them.

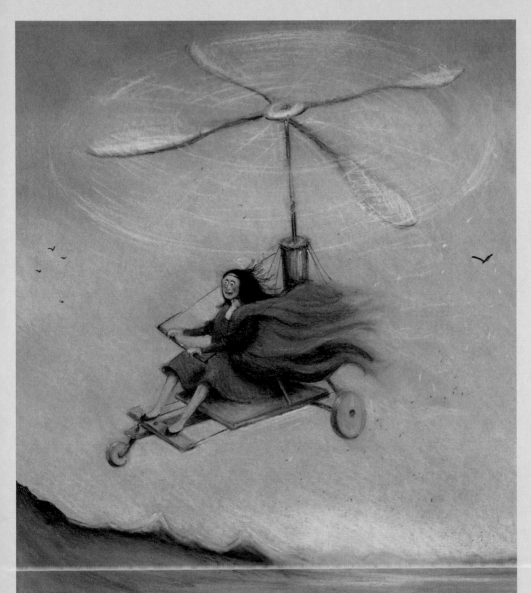

A few years after Leonardo
painted her portrait, Lisa
disappeared whilst flying
an experimental helicopter
over the Alps.

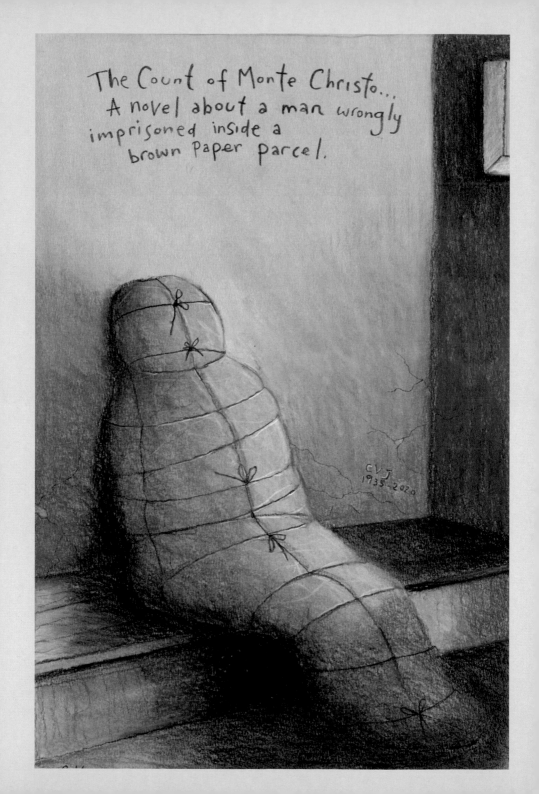

The Count of Monte Christo...
A novel about a man wrongly
imprisoned inside a
brown paper parcel.

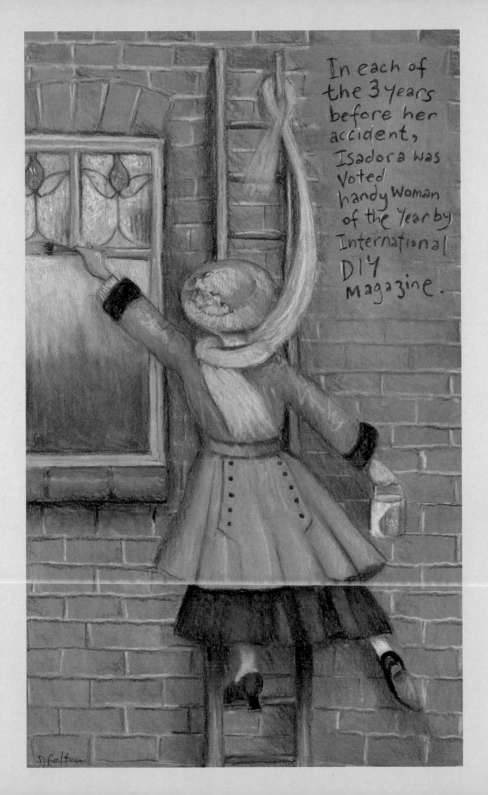

In each of the 3 years before her accident, Isadora was voted handy woman of the Year by International DIY Magazine.

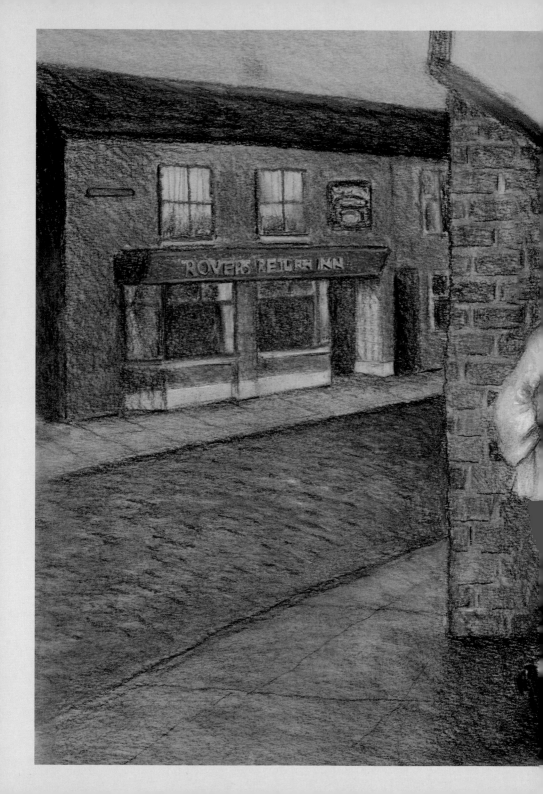

Mr and Mrs Andrews, the latest characters to join the cast of Coronation street, were not popular with the viewers.

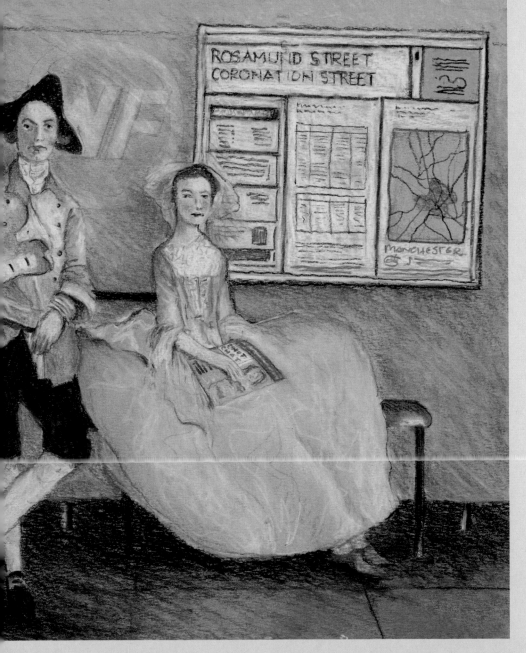

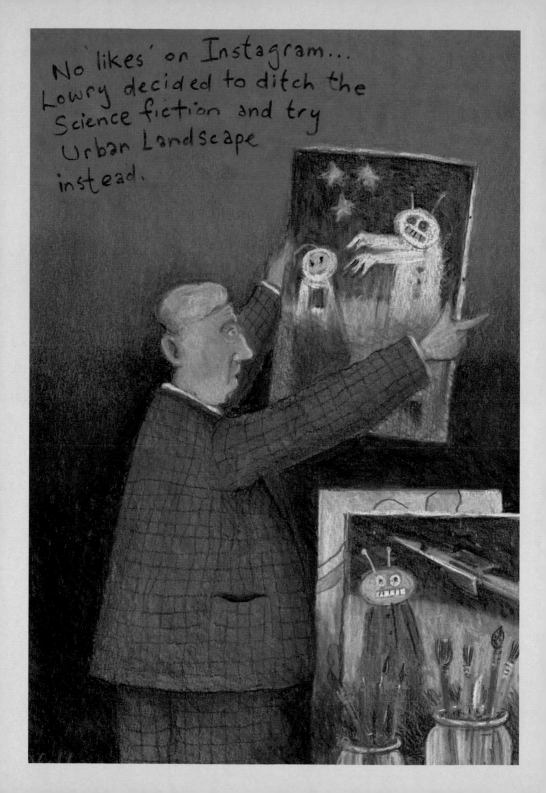

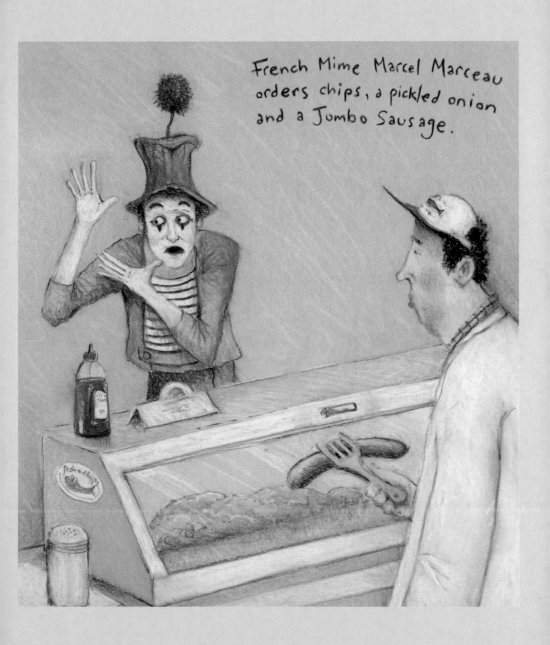

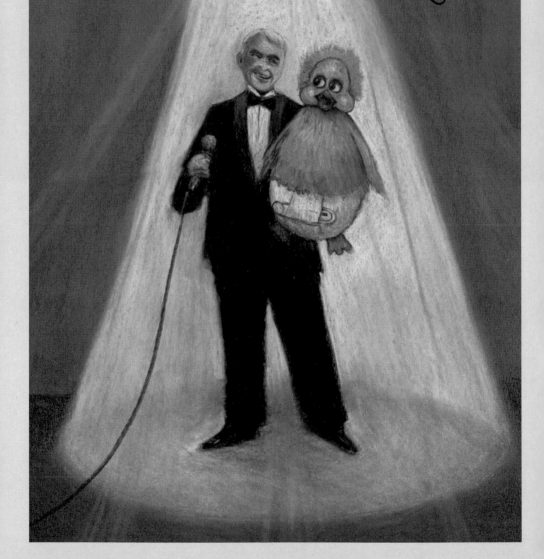

Winter Gardens Blackpool.
Sinatra gets to duet on Orville's song.

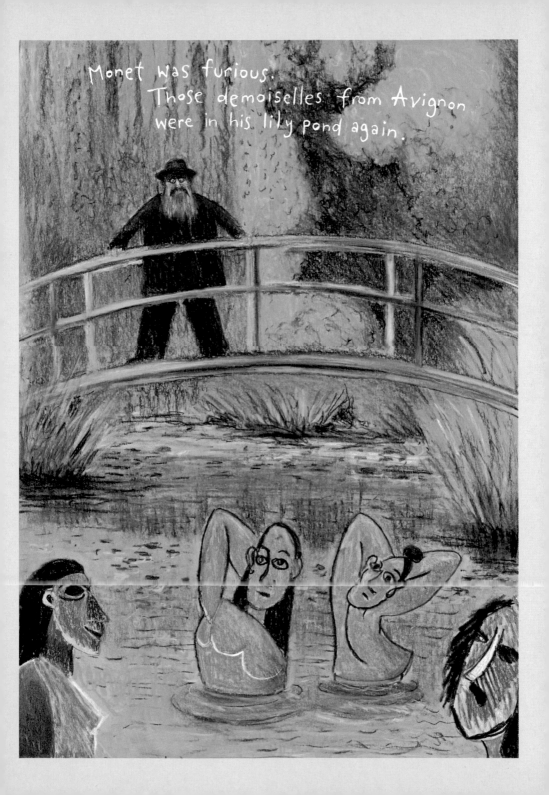

John Paul explained that there is no God, and that he'd be better off finding meaning in his own existence.

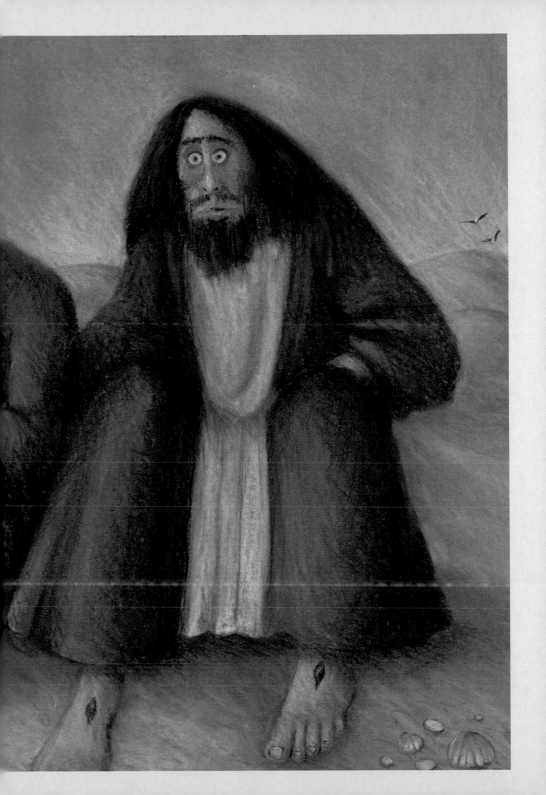

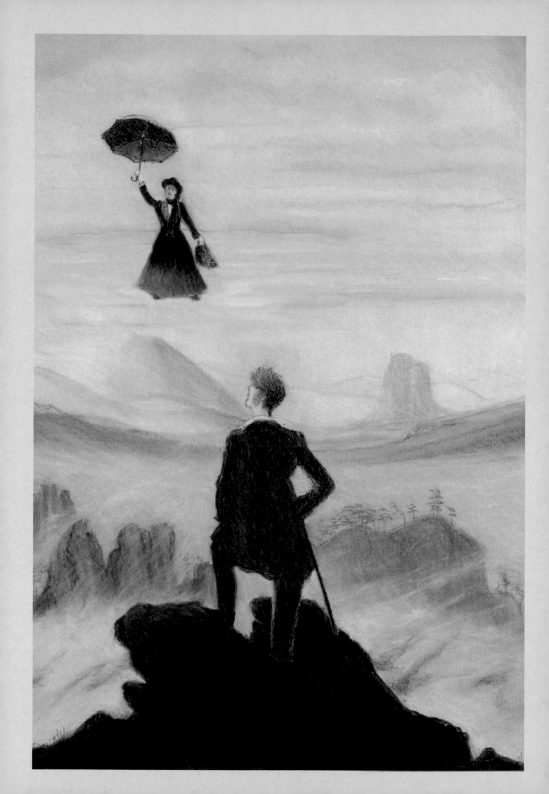

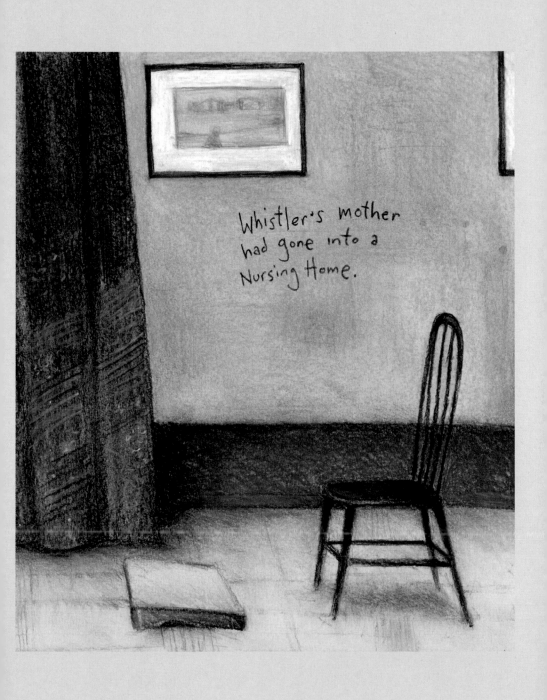

Whistler's mother
had gone into a
Nursing Home.

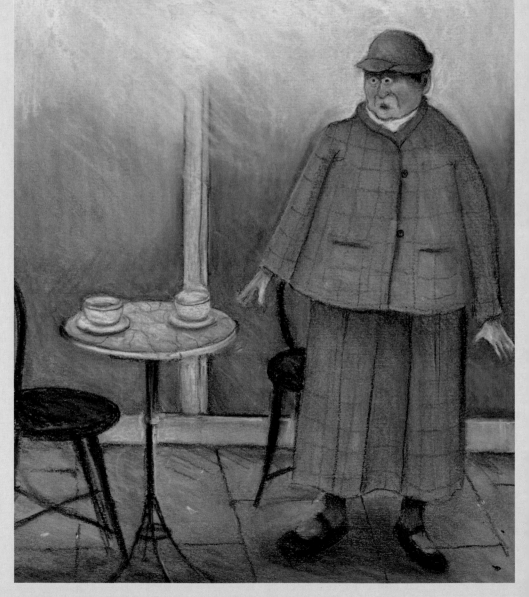

The moment Gertrude Stein realised that Jean Genet had nicked her handbag.

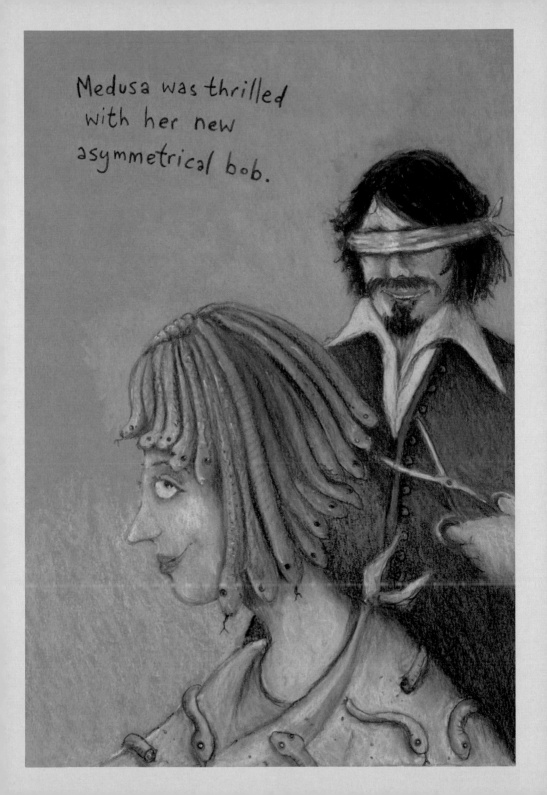

The pre breakfast race
for a sunlounger
had begun.

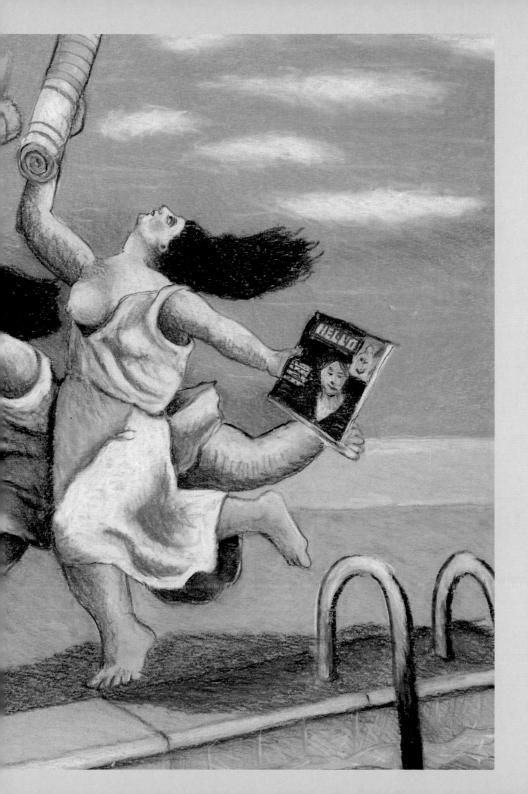

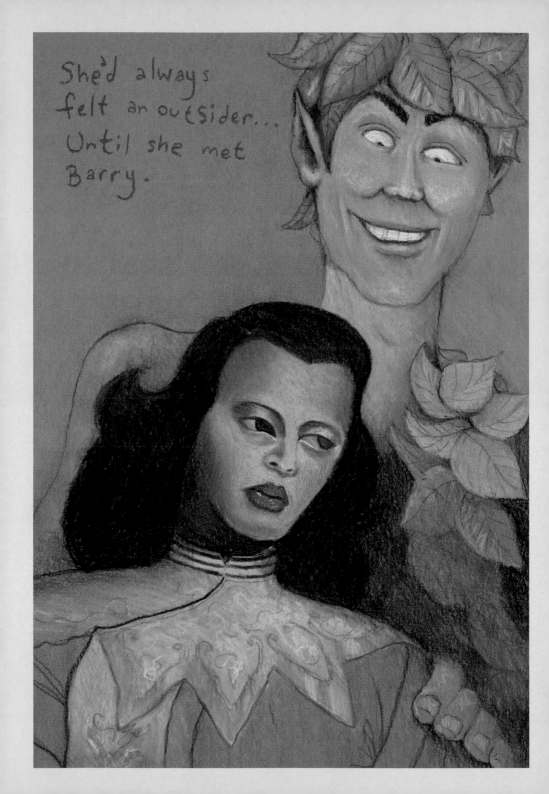

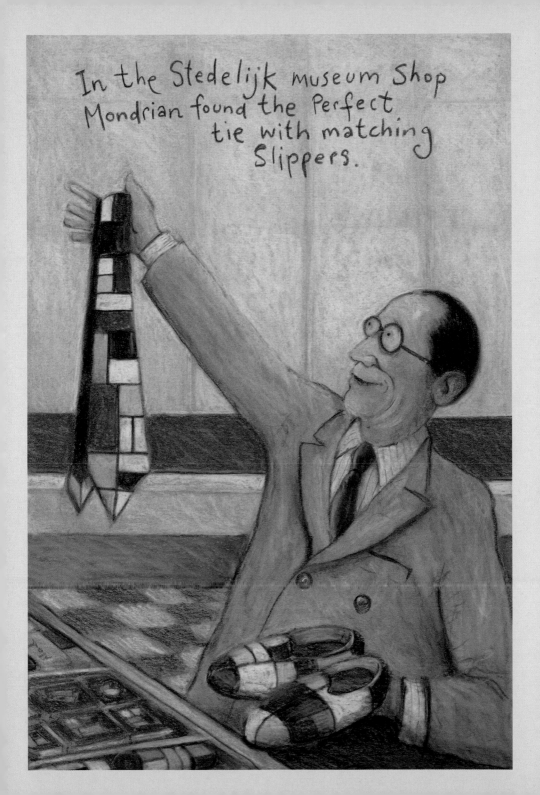

King Oedipus had nipped out
to buy a Big Mac and fries
for his Mother.

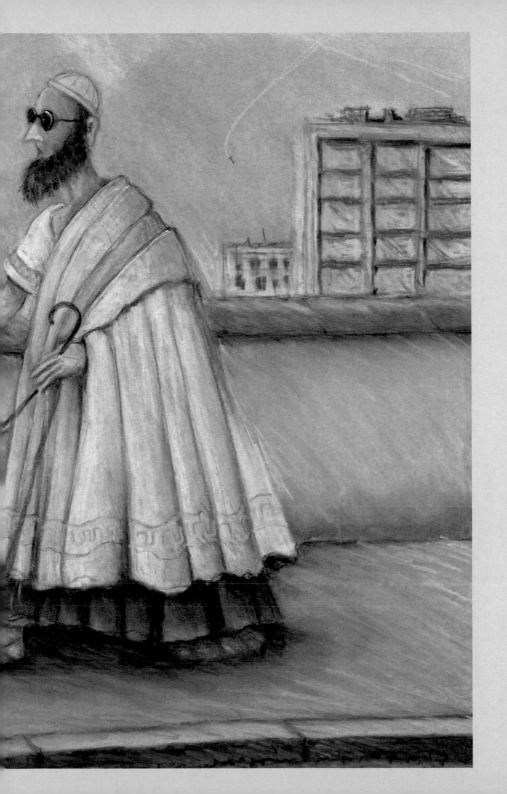

A Room of One's Own, Orlando, Mrs Dalloway...
Virginia was proud of all her books; but
her real passion was making her own
Sausages.

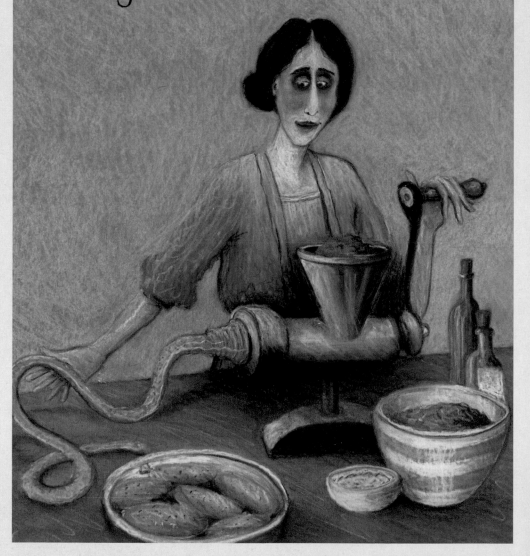

Schrödinger takes his cat for a walk.

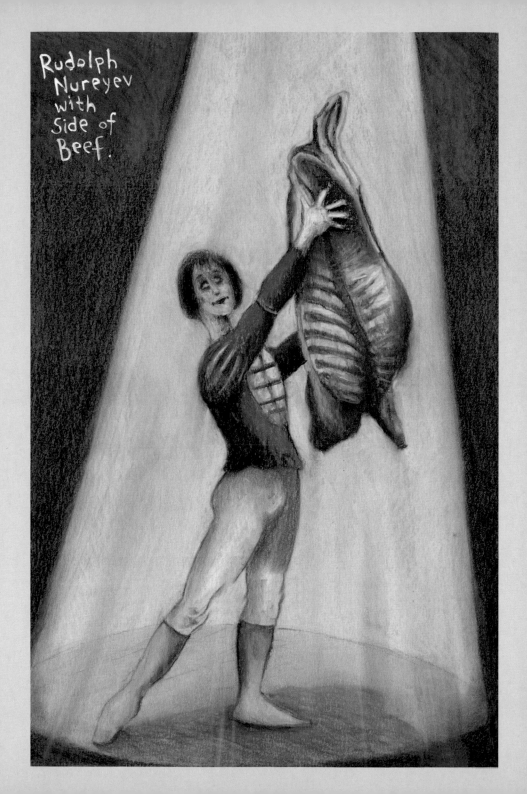

Rudolph Nureyev with Side of Beef.

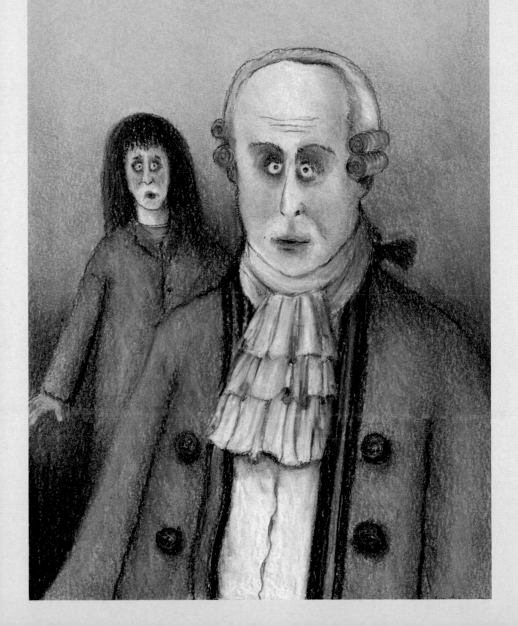

There was no reasoning with Kant.

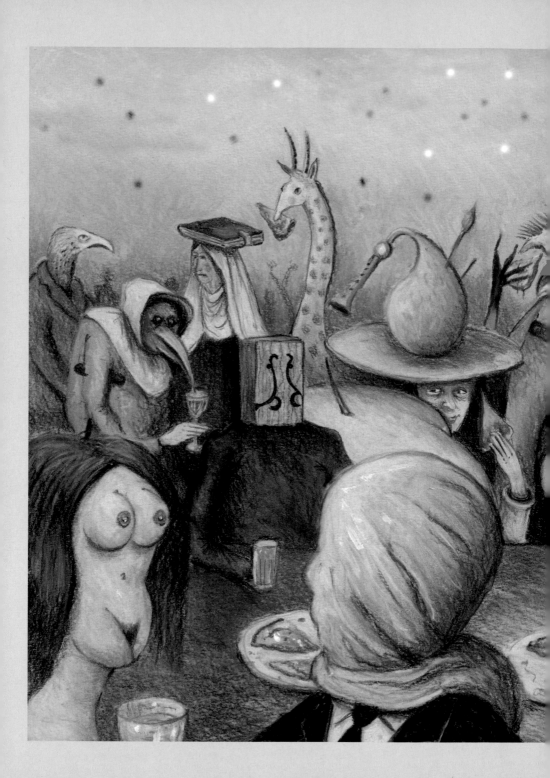

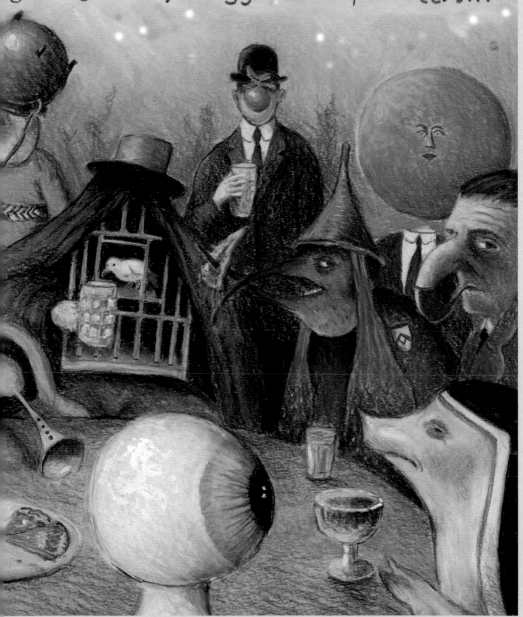

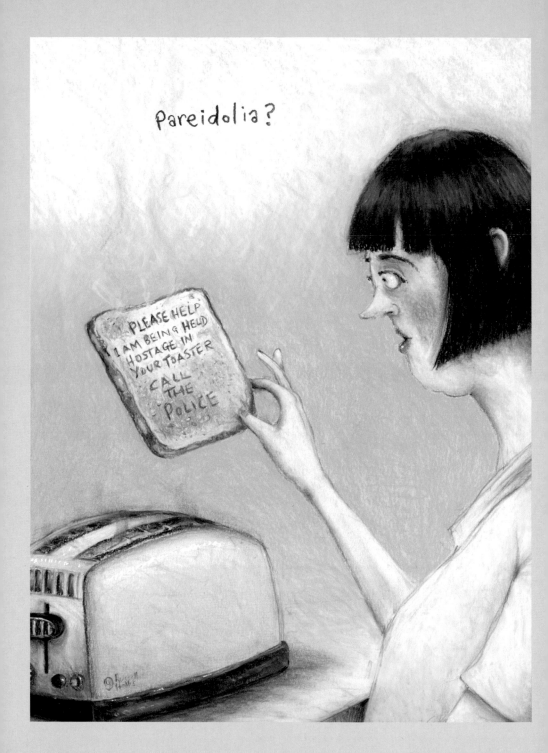

Cast and crew:

Adolf Hitler, Albert Camus, Alexandre Dumas, Andy Goldsworthy, Andy Warhol, Anne Hathaway, Barbara Cartland, Beatrix Potter, Caravaggio, Carl Jung, Caspar David Friedrich, Celebes, Christo, Claude Monet, Clint Eastwood, David Bowie, D. H. Lawrence, Erwin Schrödinger, Frank Sinatra, Friedrich Nietzsche, George Orwell, Gertrude Stein, Gustav Klimt, Henri Toulouse-Lautrec, Hieronymus Bosch, Immanuel Kant, Infanta Margarita Teresa, Isadora Duncan, Jane Austen, Jean Genet, Jean-Paul Sartre, Jeff Koons, Jesus Christ, J. M. Whistler, John Cage, Karl Marx, Ken Barlow, King Nebuchadnezzar, King Oedipus, Leonardo da Vinci, Lisa del Giocondo, L. S. Lowry, Ludwig van Beethoven, Marcel Duchamp, Marcelle Lender, Marcel Marceau, Mary Poppins, Mary Shelley, Max Ernst, Medusa, Mr and Mrs Andrews, Napoleon Bonaparte, Orville the Duck, Otto Dix, Pablo Picasso, Paul Delaroche, Pieter Bruegel the Elder, Piet Mondrian, Pope Innocent X, René Magritte, Rudolph Nureyev, Salvador Dalí, Sandro Botticelli, Sigmund Freud, Sisyphus, Sylvia von Harden, The de Groot family, The Green Lady, The Jolly Green Giant, Thomas Gainsborough, Urizen, Vaslav Nijinsky, Venus, Vincent van Gogh, Virginia Woolf, Vladimir Tretchikoff, William Blake, William Shakespeare, and the host of extra characters that feature in the drawings.

Acknowledgements:

Many thanks to Julie for her support, insights and encouragement, and to David B for his enthusiasm and feedback. Much appreciated.

Davecoltonart.com

Published in 2022 by
Unicorn, an imprint of Unicorn Publishing Group
5 Newburgh Street
London
W1F 7RG
www.unicornpublishing.org

ISBN 978 1 914414 57 2

Designed by newtonworks.uk
Printed by Fine Tone Ltd
10 9 8 7 6 5 4 3 2 1